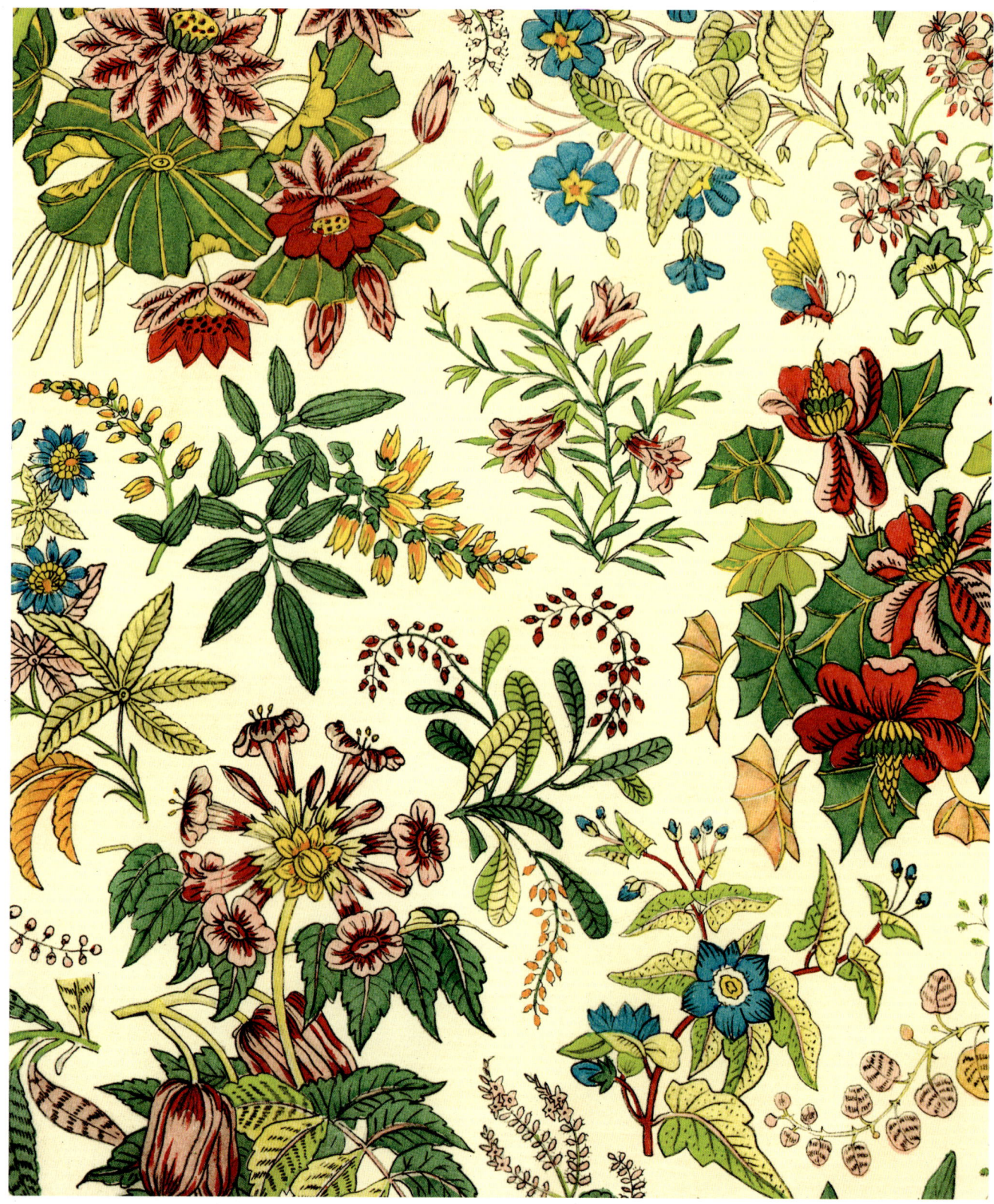

FLORAL DESIGN

MOTIFS FLORAUX

BLUMENMUSTER

ARTE FLOREALE

DISEÑO FLORAL

フローラル・デザイン

花卉與設計

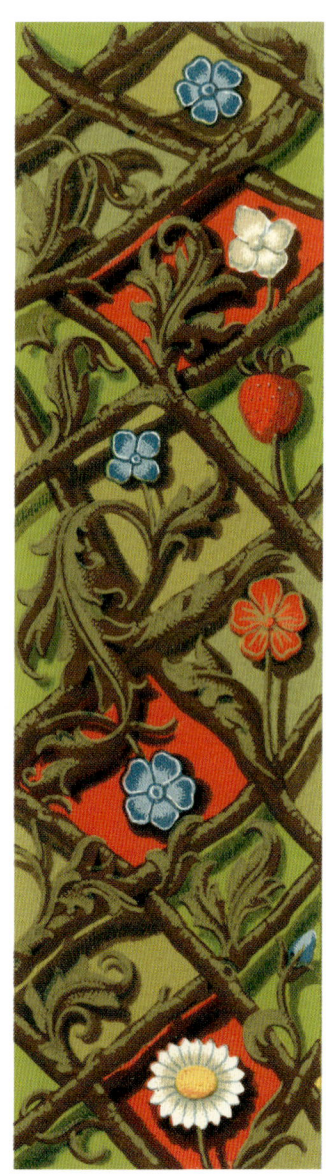

FLORAL DESIGN

DOVERPICTURA

DOVER PUBLICATIONS, Inc. | Mineola, New York

Selected and designed by Thalia Large and Alan Weller.

Copyright © 2004 by Dover Publications, Inc.
Digital images copyright © 2004 by Dover Publications, Inc.
All rights reserved.

Floral Design is a new work, first published by Dover Publications, Inc., in 2004.

The illustrations contained in this book and CD-ROM belong to the Dover Pictura Electronic Design Series. They are permission-free, and may be used as a graphic resource provided no more than ten images are included in the same publication or project. The use of any of these images in book, electronic, or any other format for resale or distribution as royalty-free graphics is strictly prohibited.

For permission to use more than ten images, please contact:
Permissions Department
Dover Publications, Inc.
31 East 2nd Street
Mineola, NY 11501
rights@doverpublications.com

The CD-ROM file names correspond to the images in the book. All of the artwork stored on the CD-ROM can be imported directly into a wide range of design and word-processing programs on either Windows or Macintosh platforms. No further installation is necessary.

International Standard Book Number: 0-486-99637-9

Manufactured in Hong Kong
Dover Publications, Inc., 31 East 2nd Street, Mineola, NY 11501
www.doverpublications.com

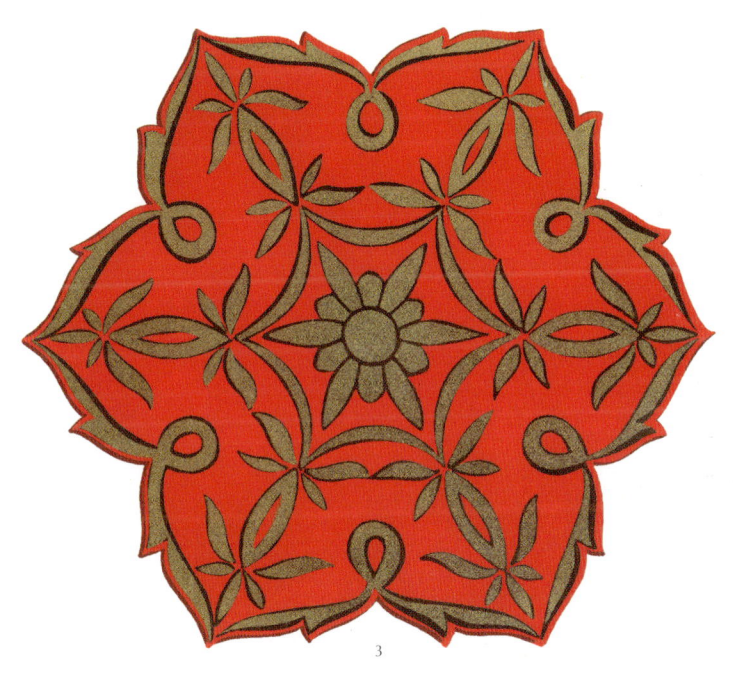
3

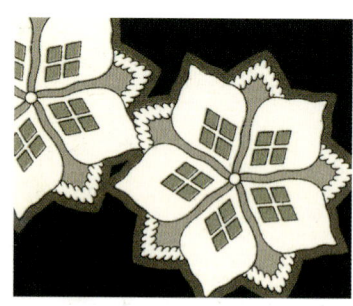

4

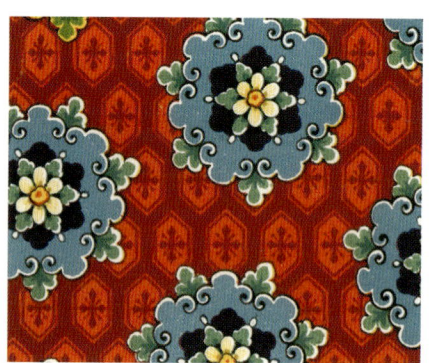

5

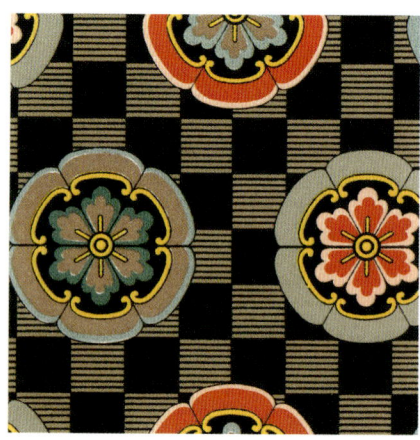

6

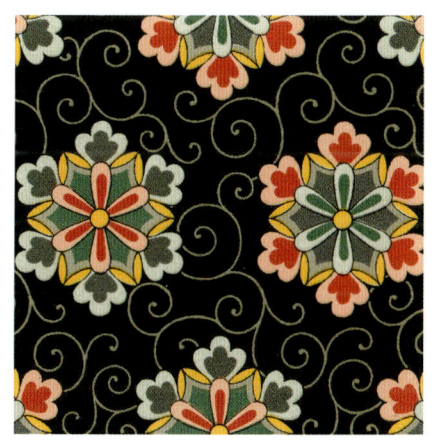

7

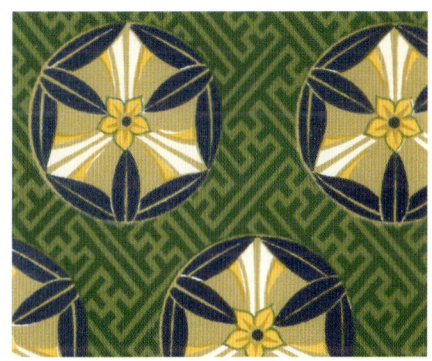

8

9

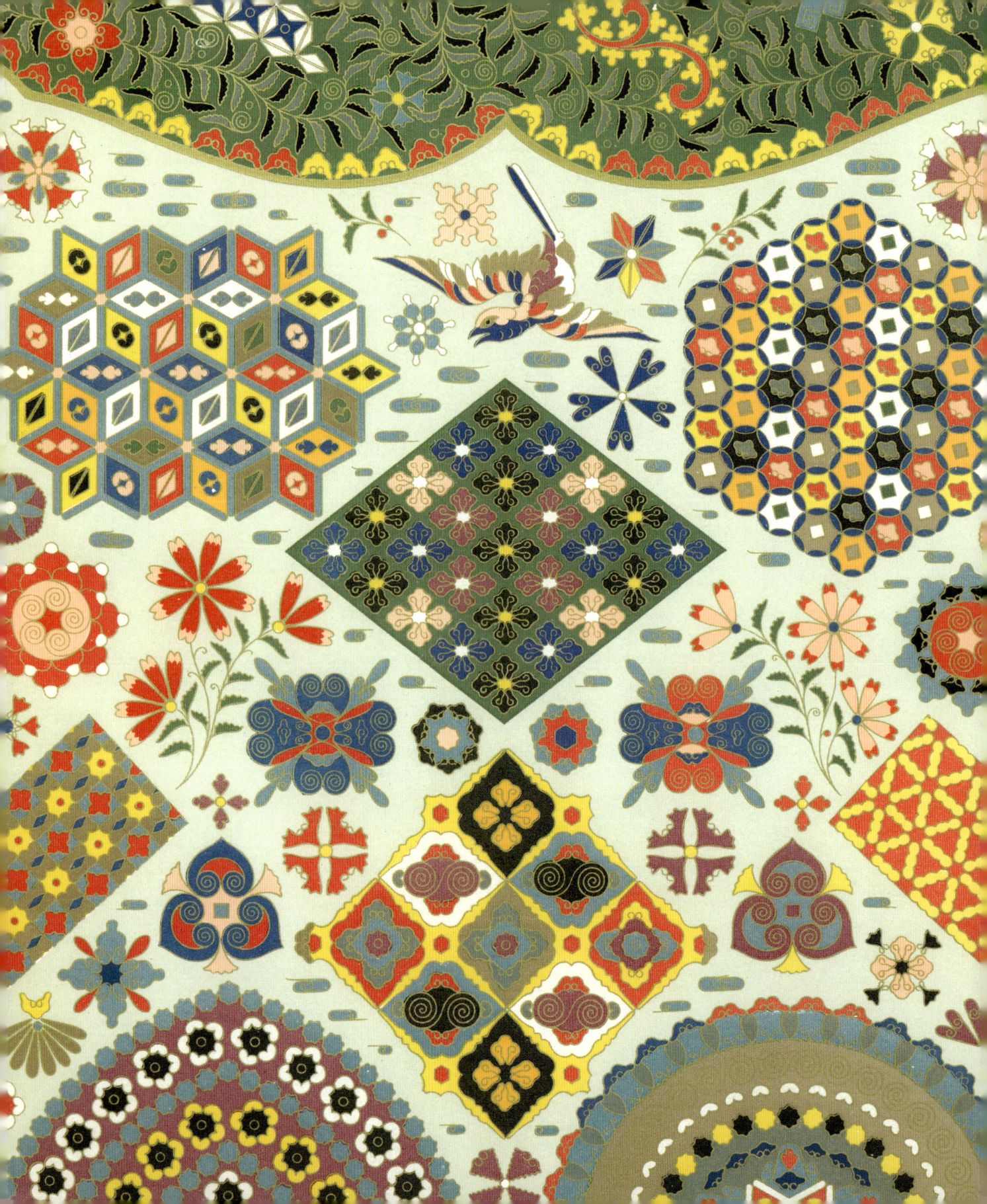

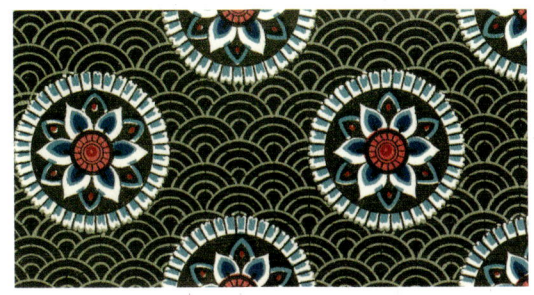
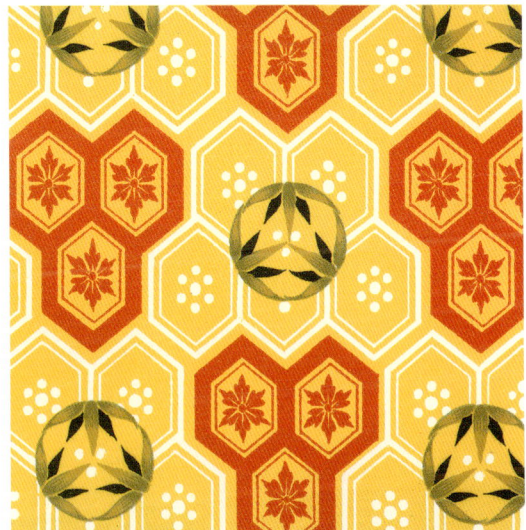
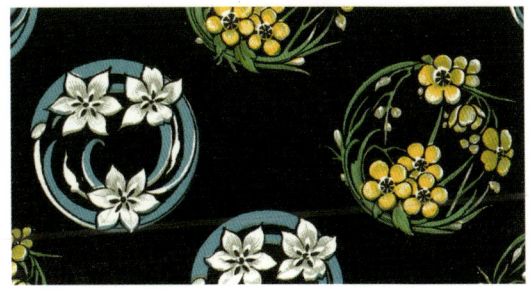

11–13

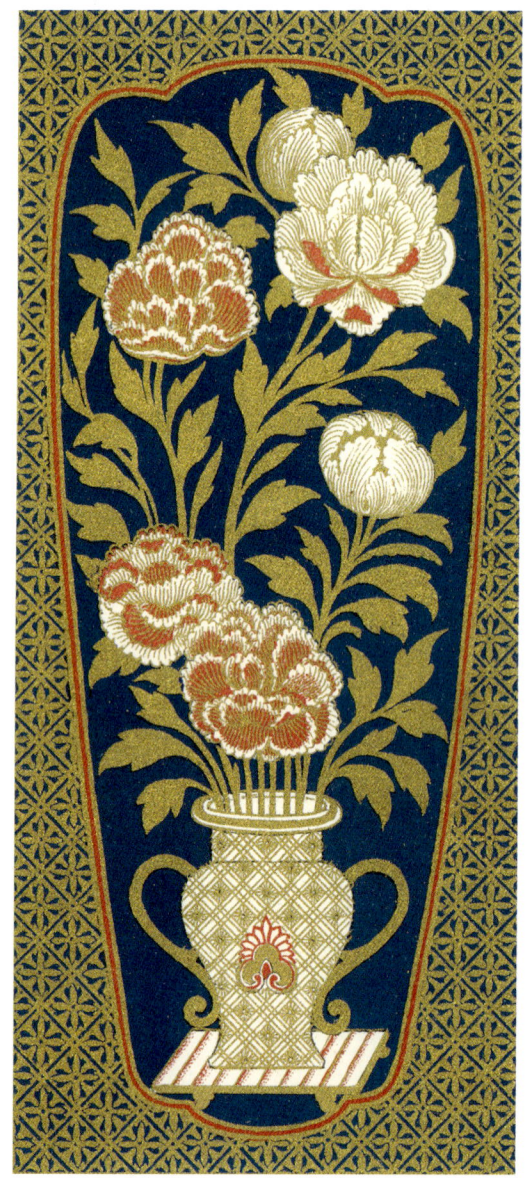
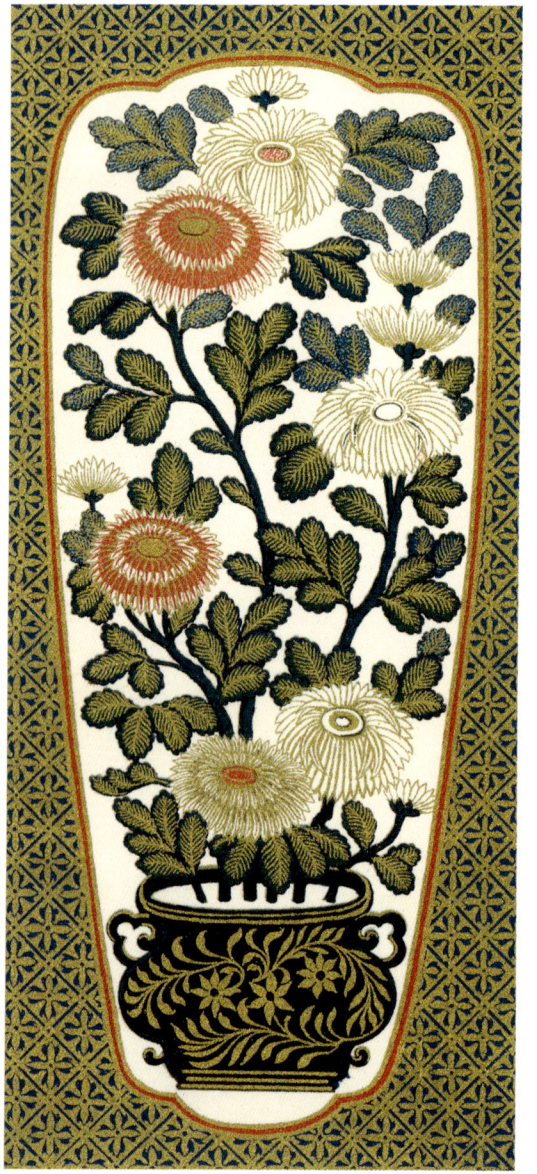

14 15

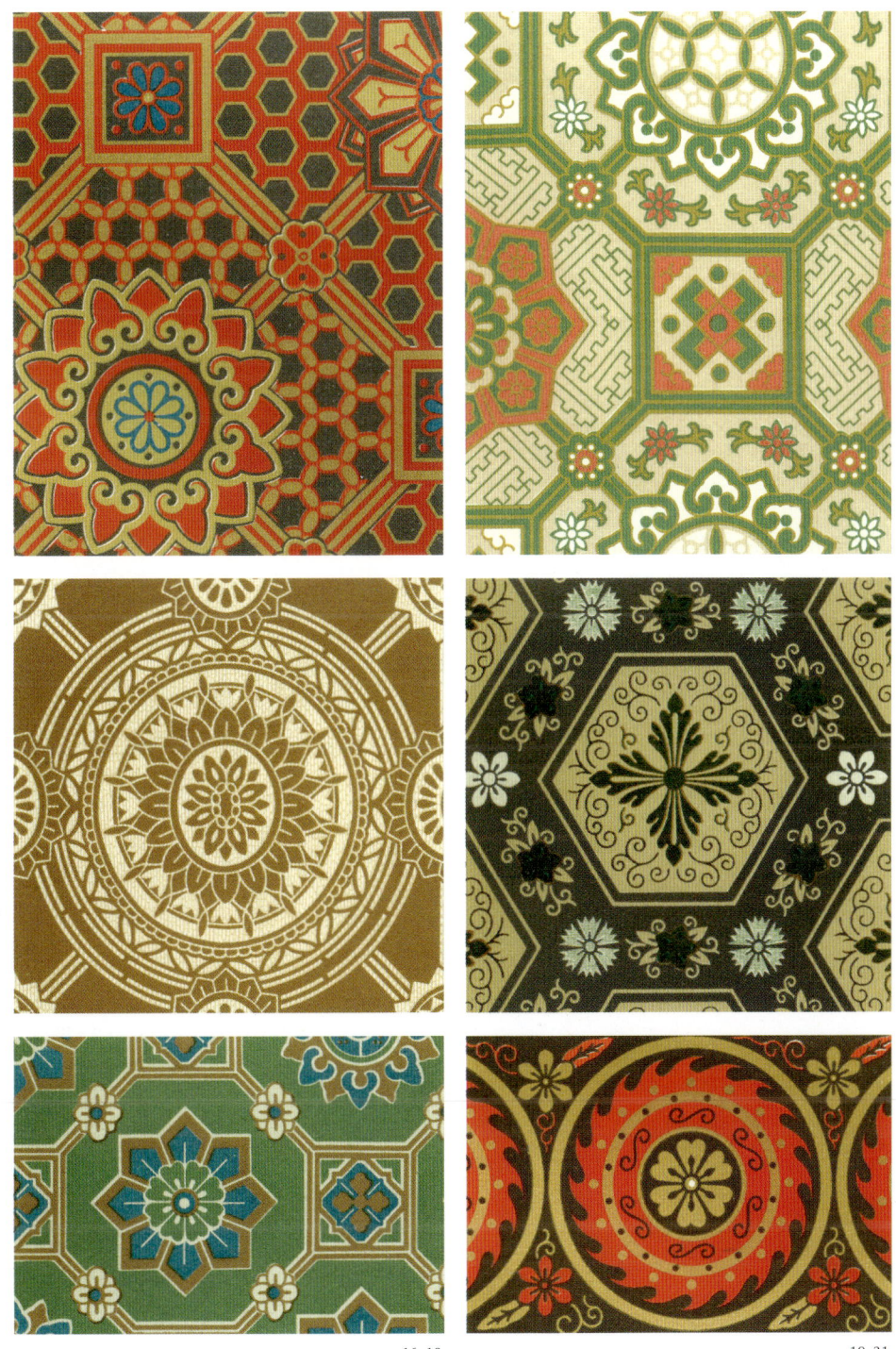

16–18 19–21

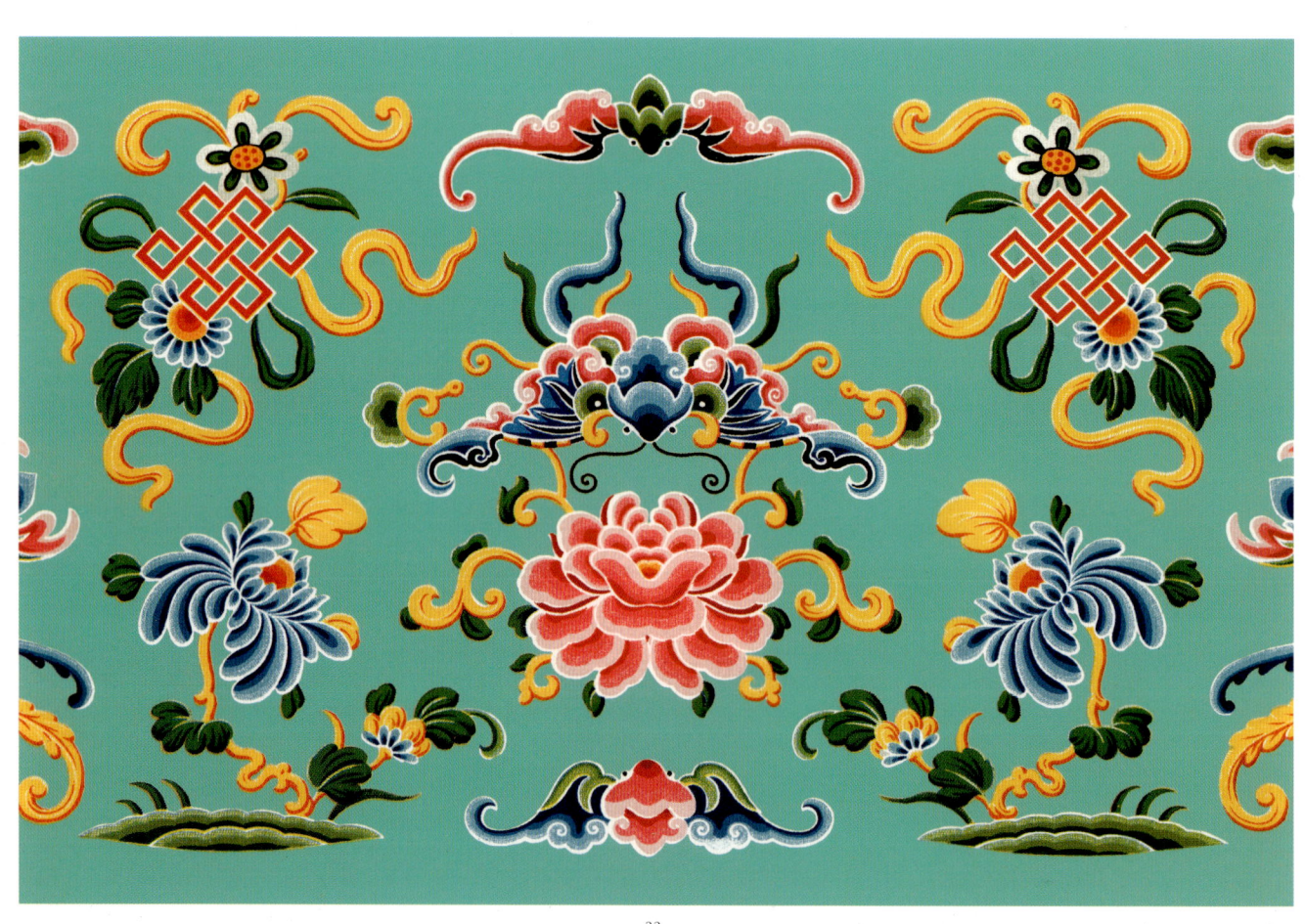

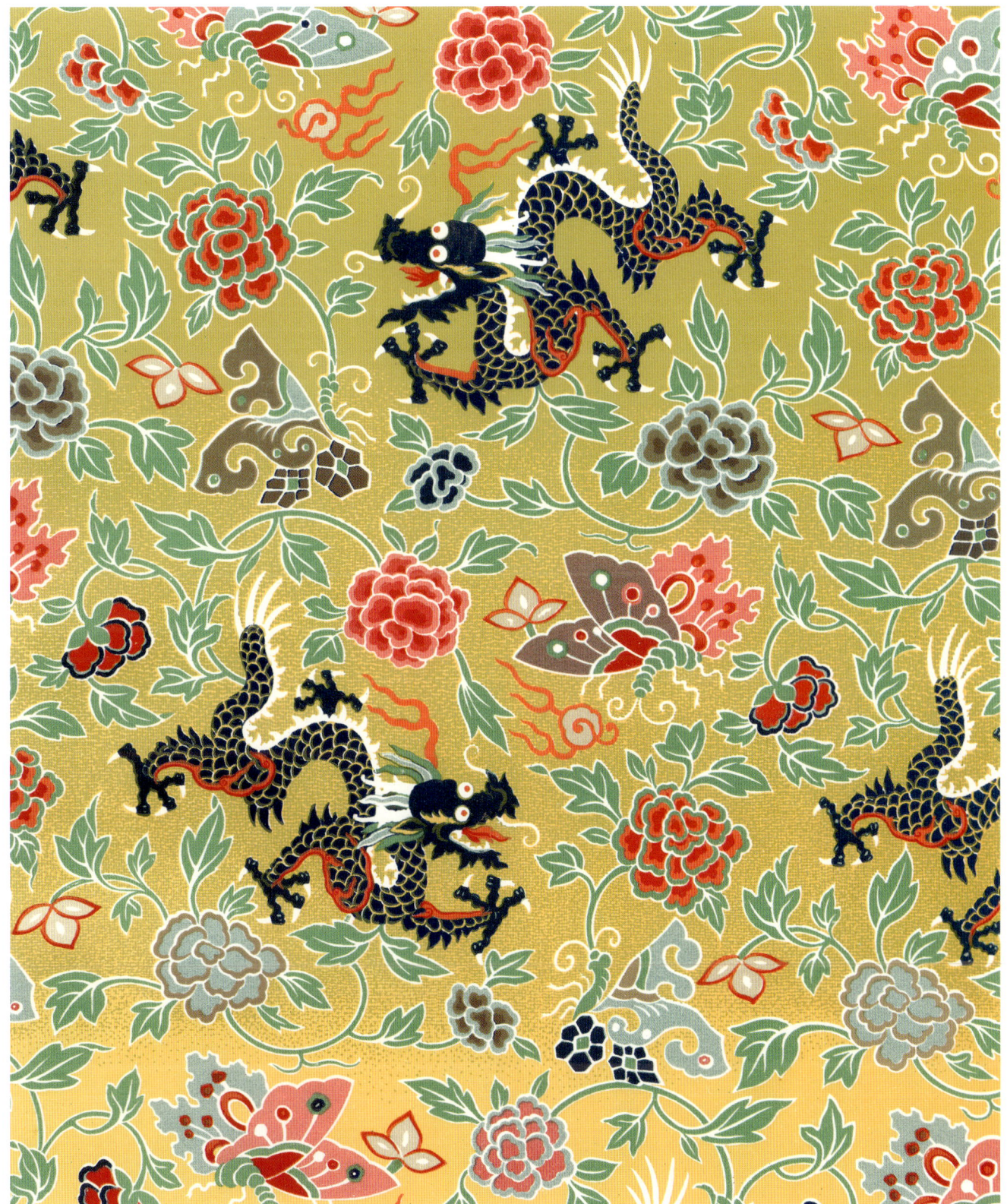

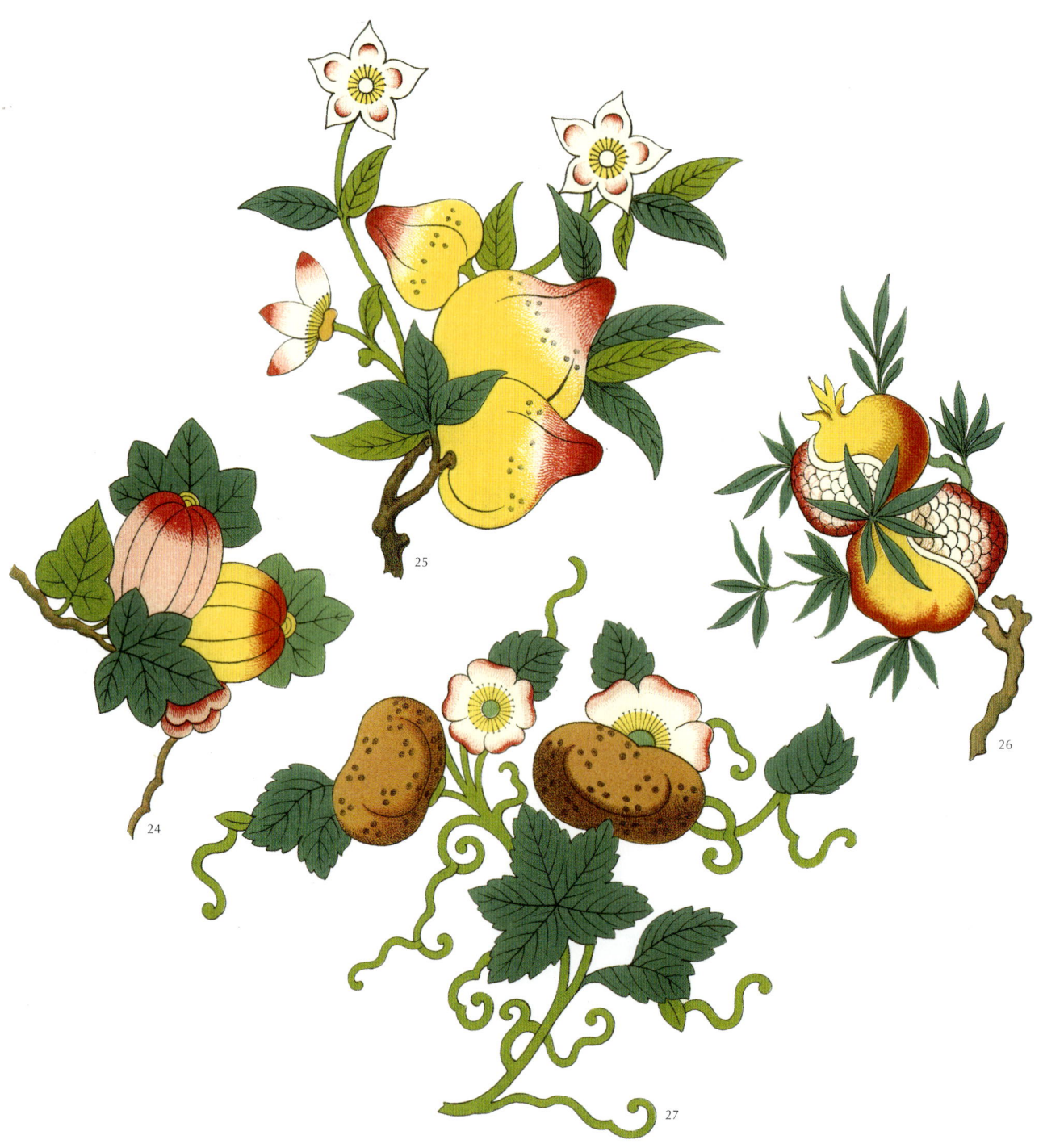

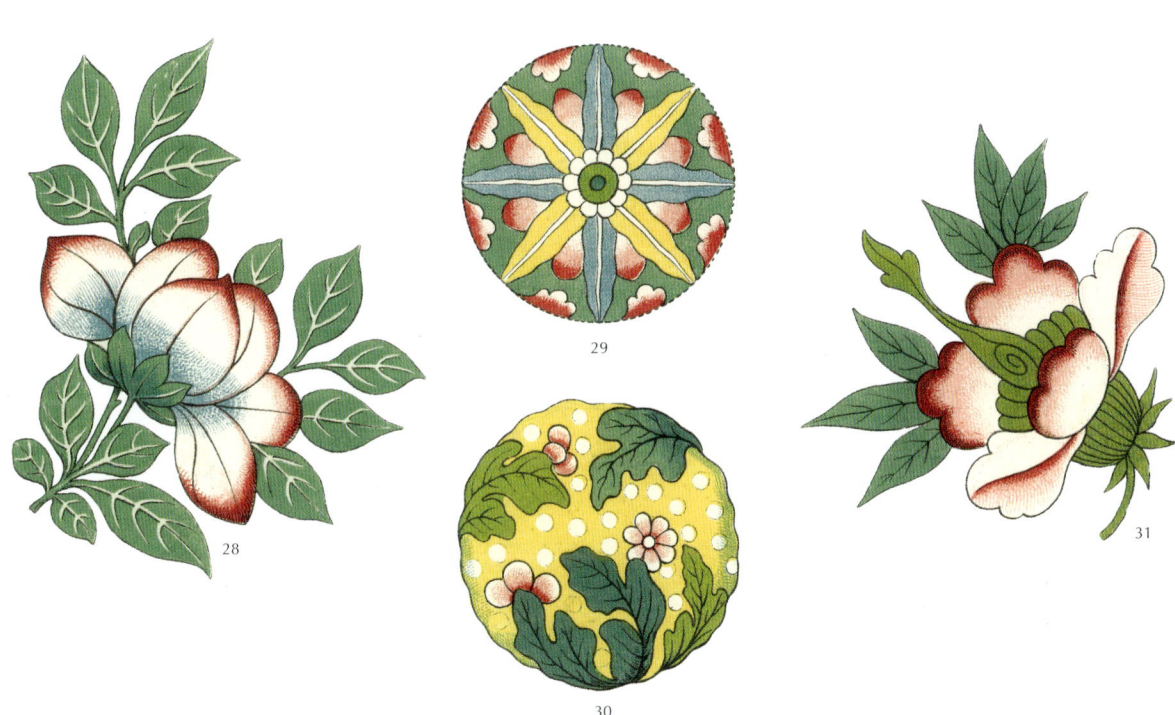

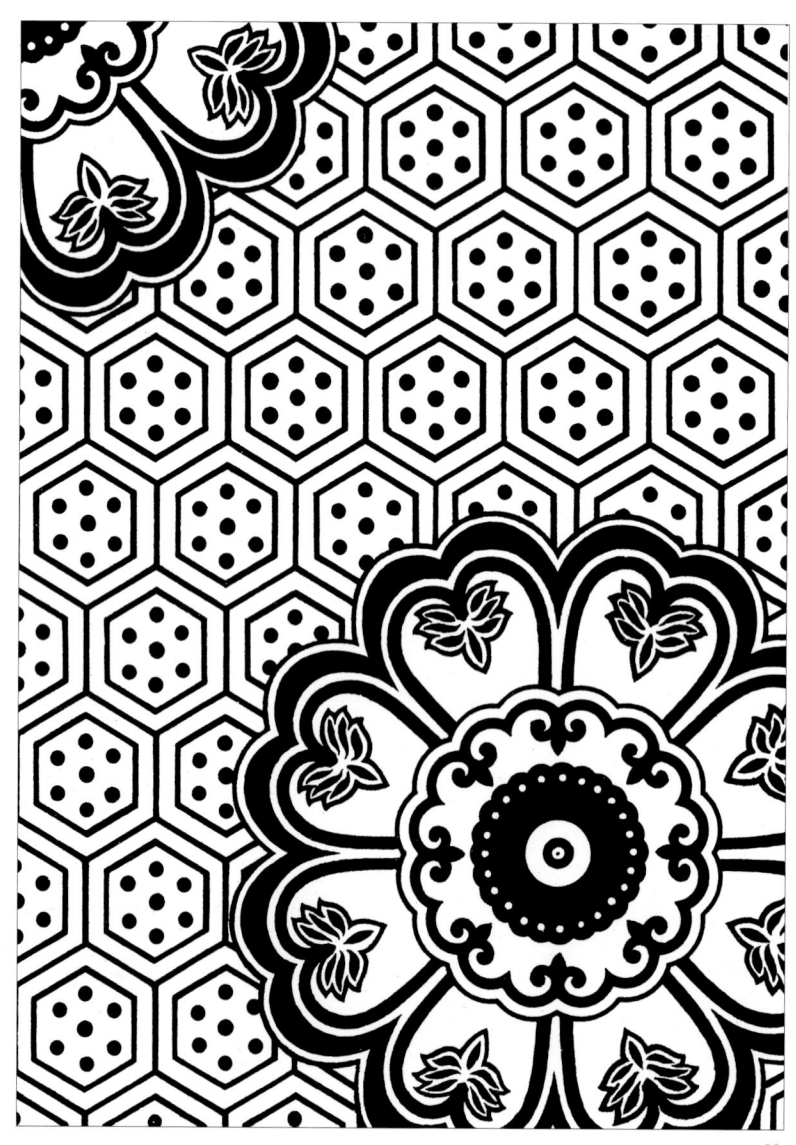

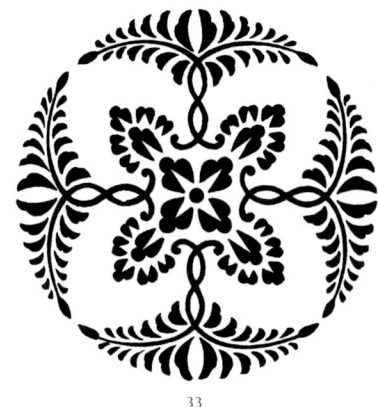
33

34

35

36

37

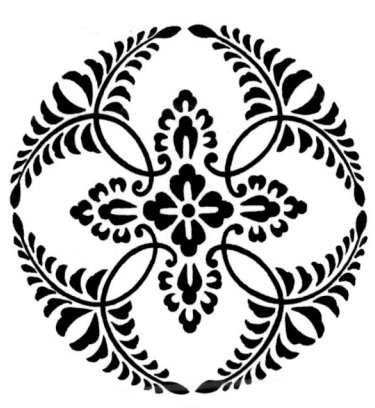
38

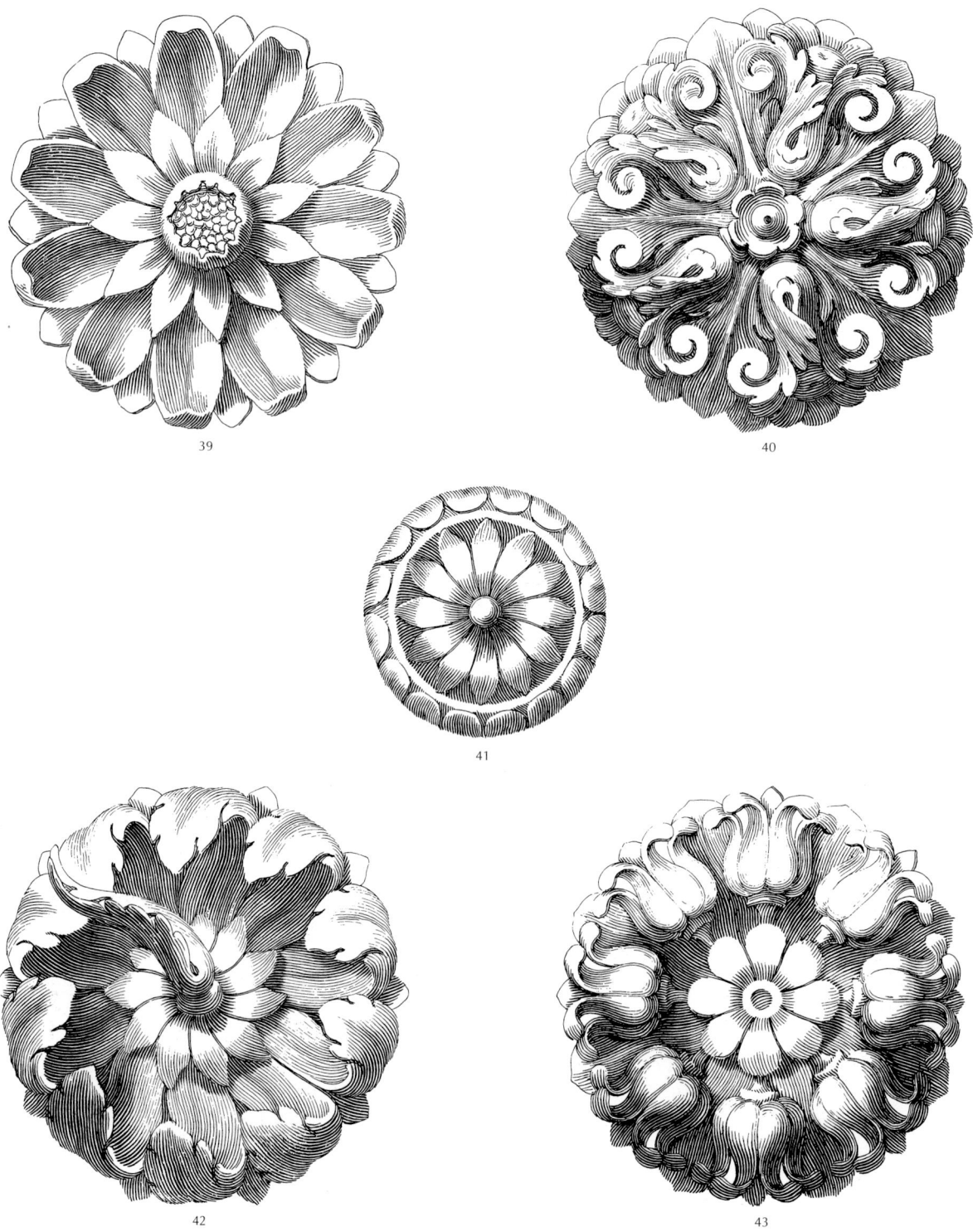

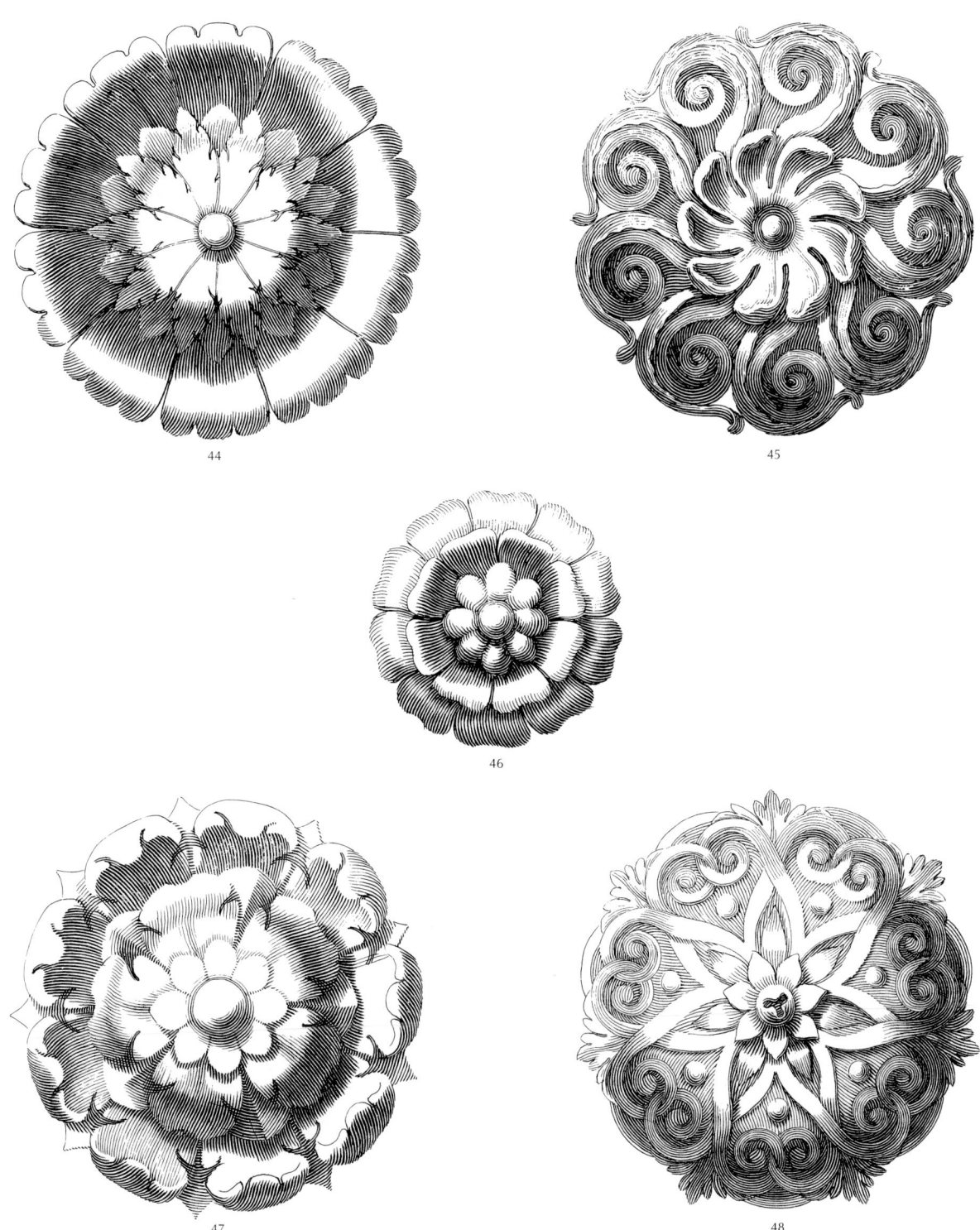

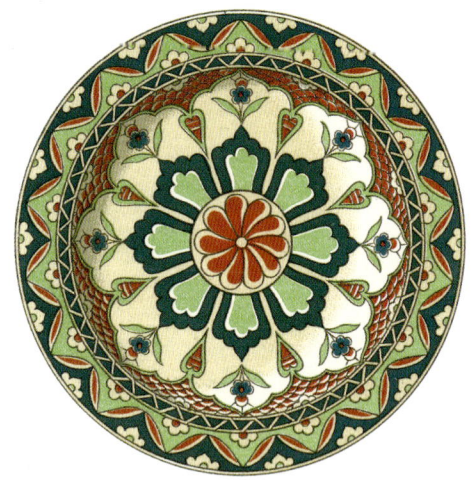
49

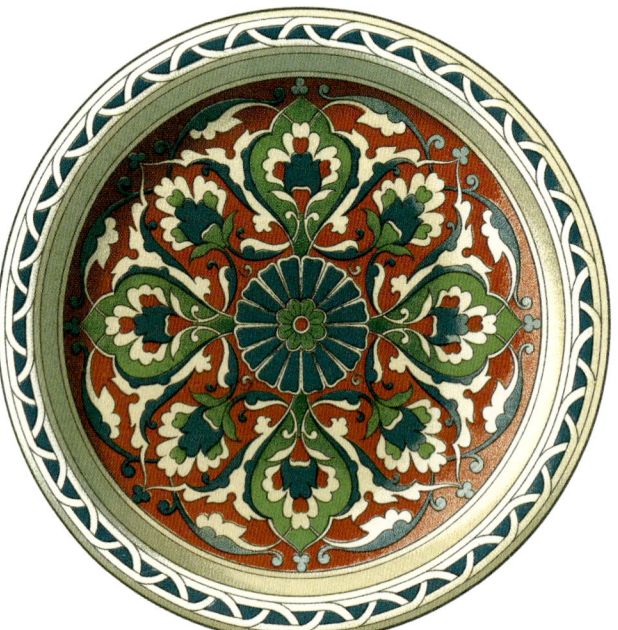
50

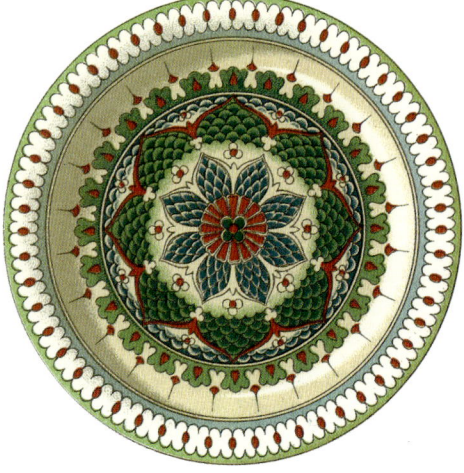
51

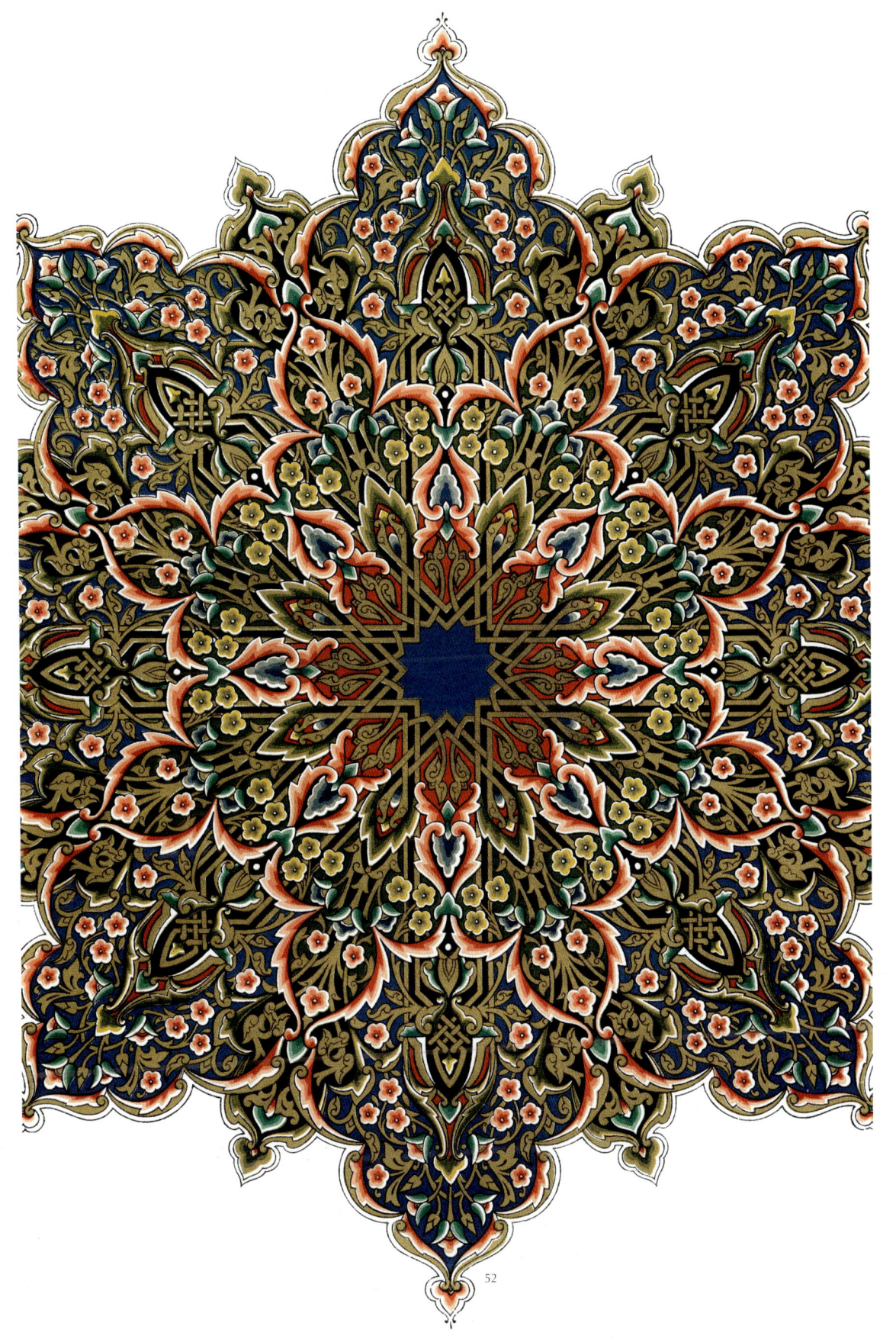

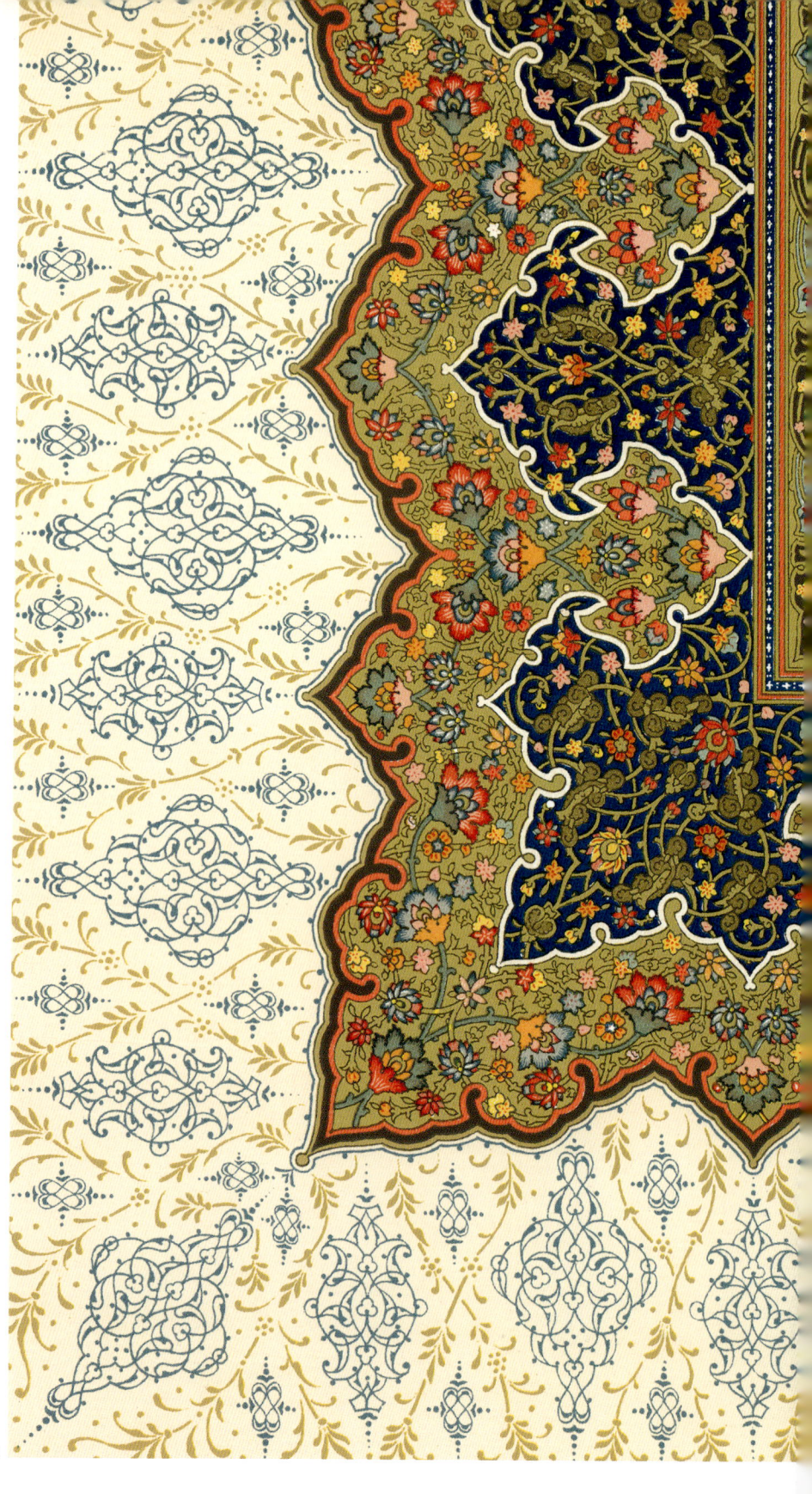

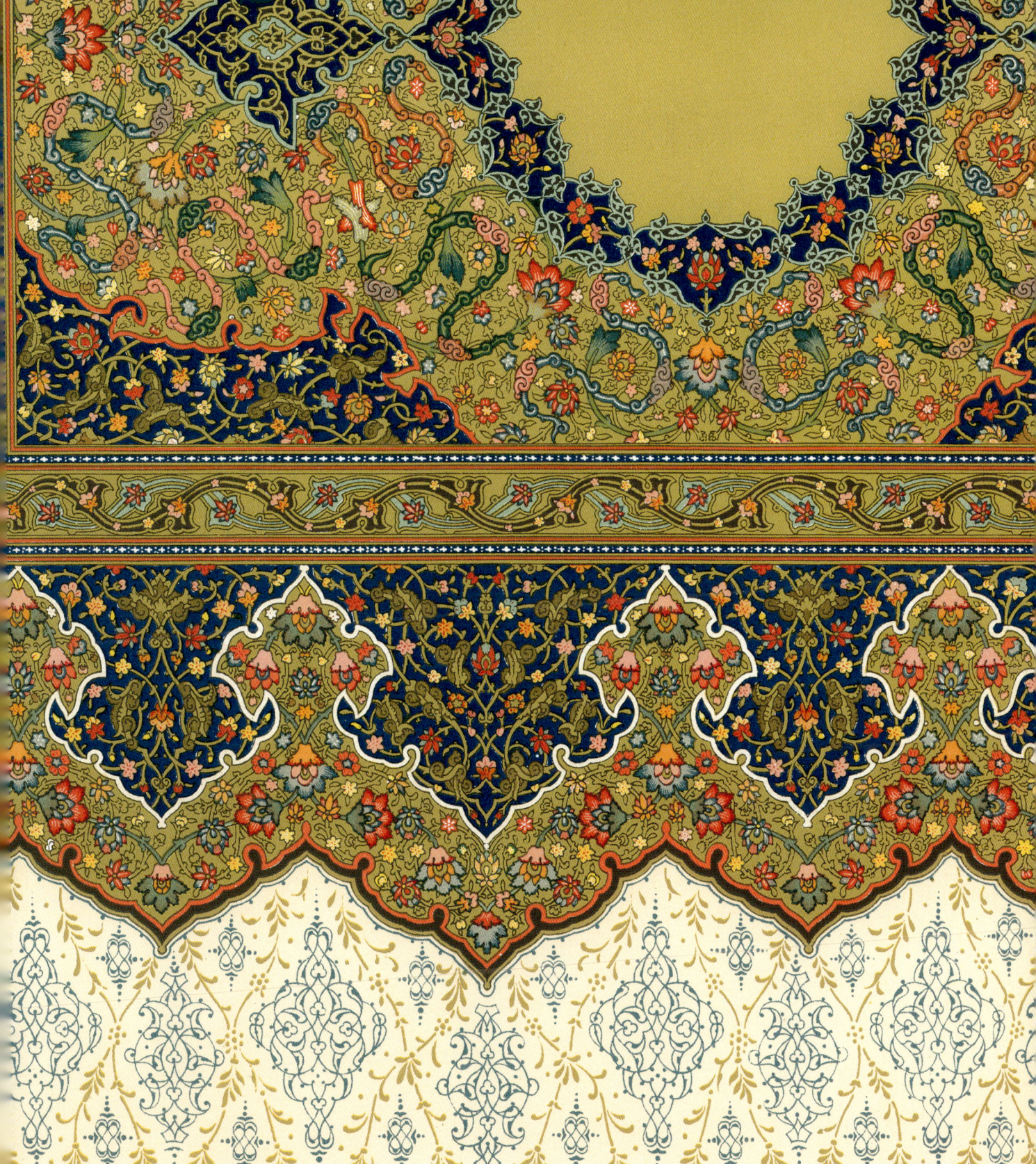

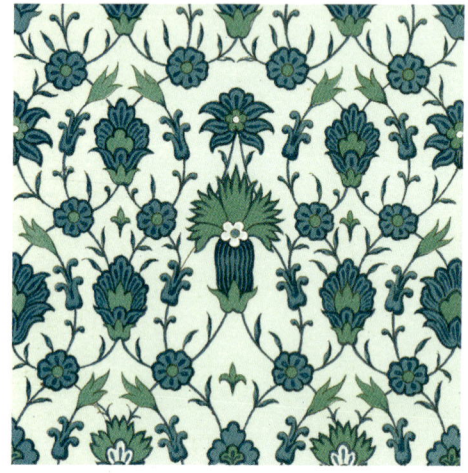
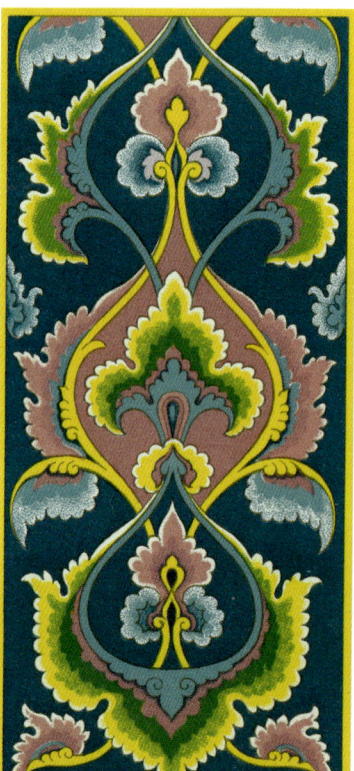
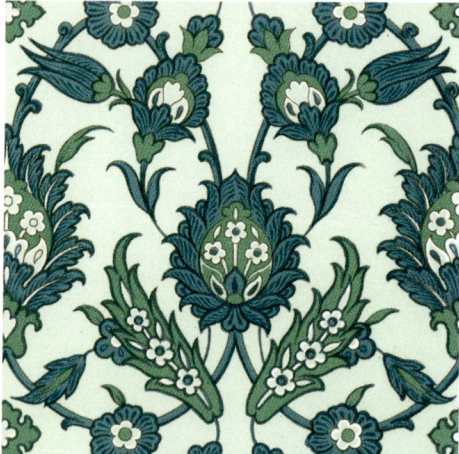
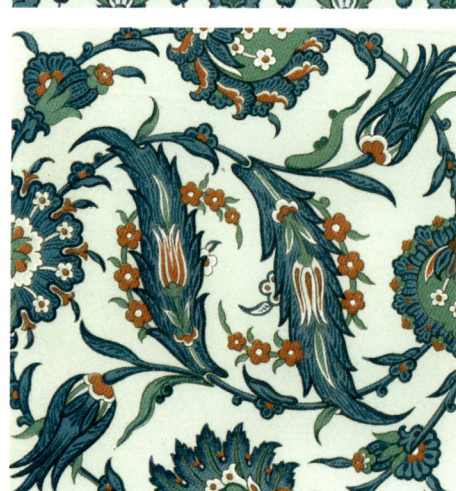

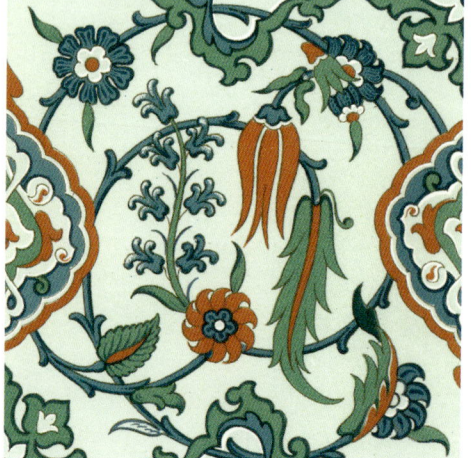

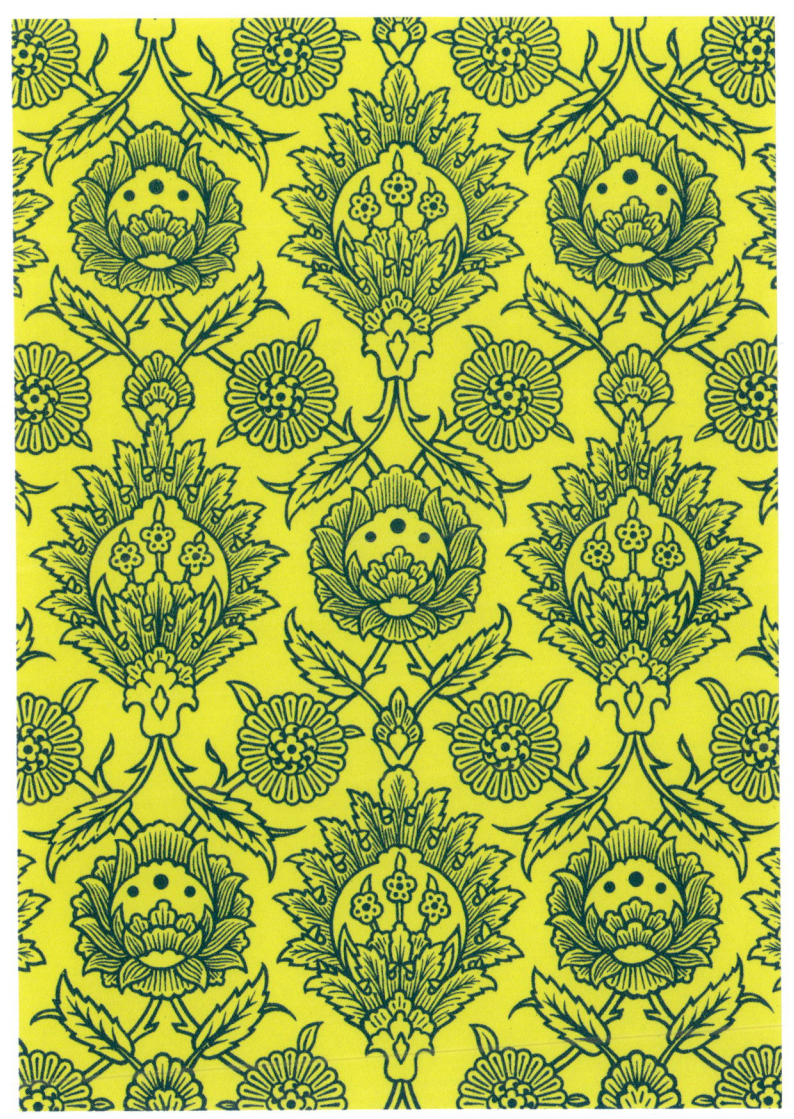
55

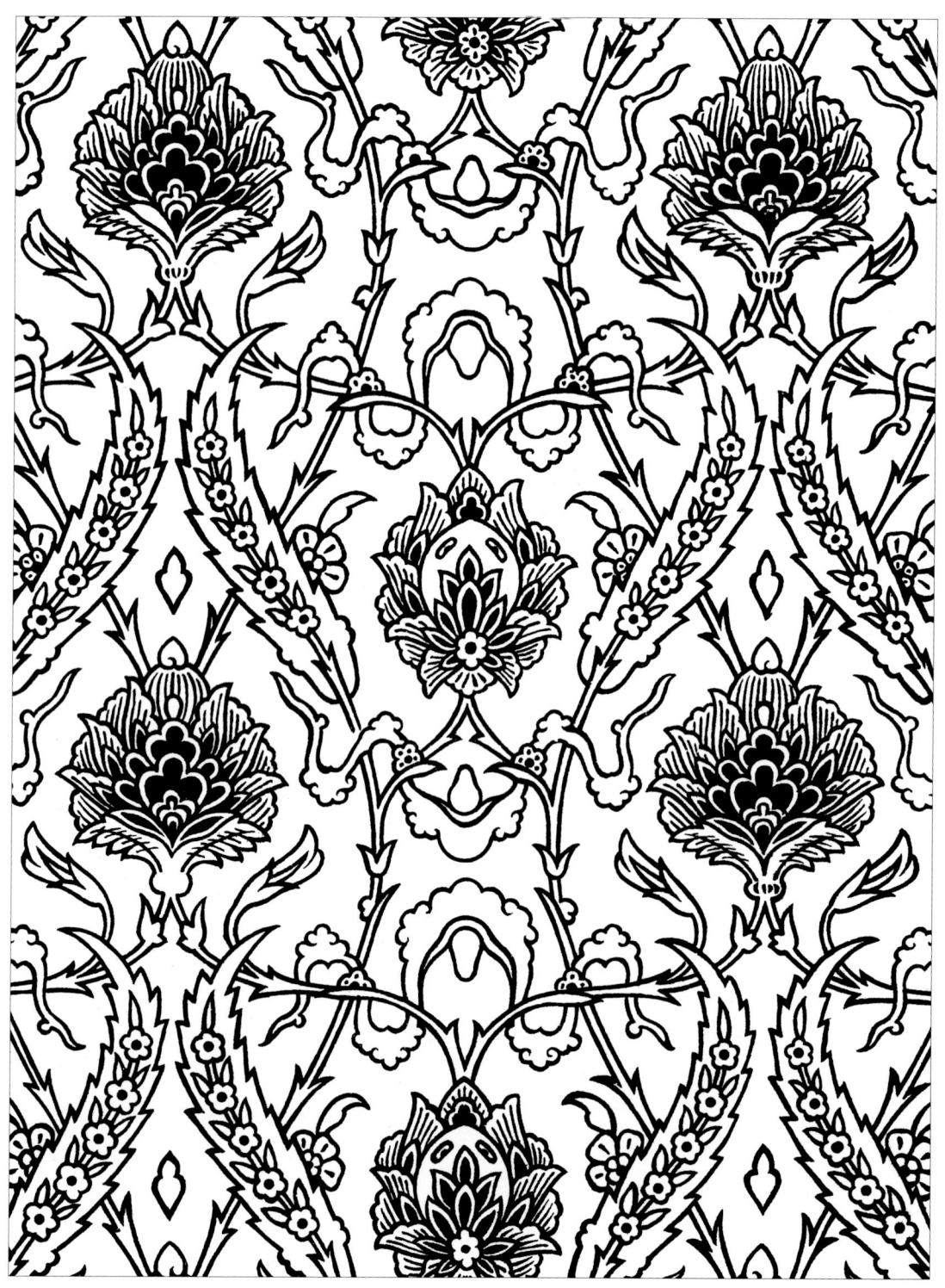

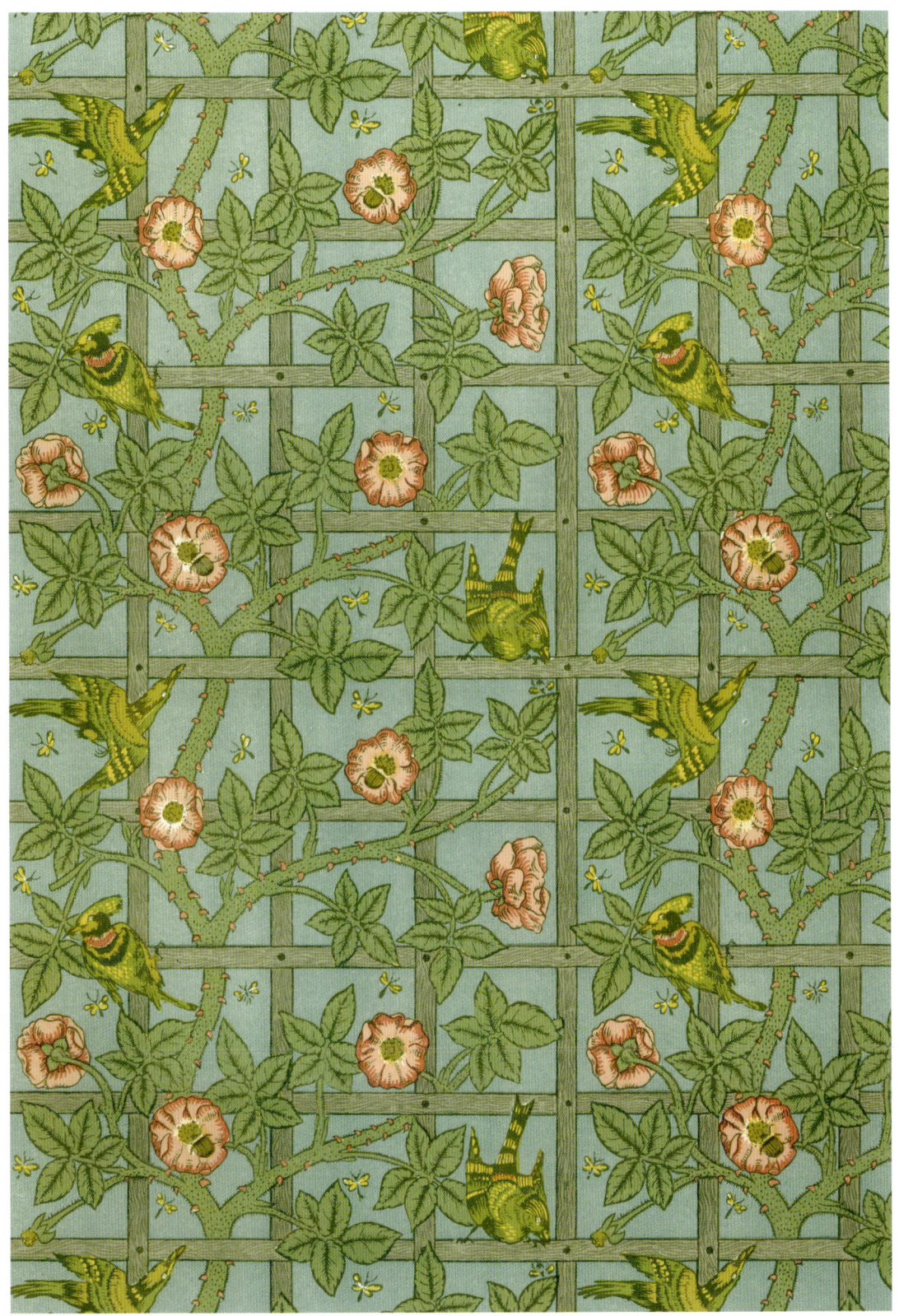

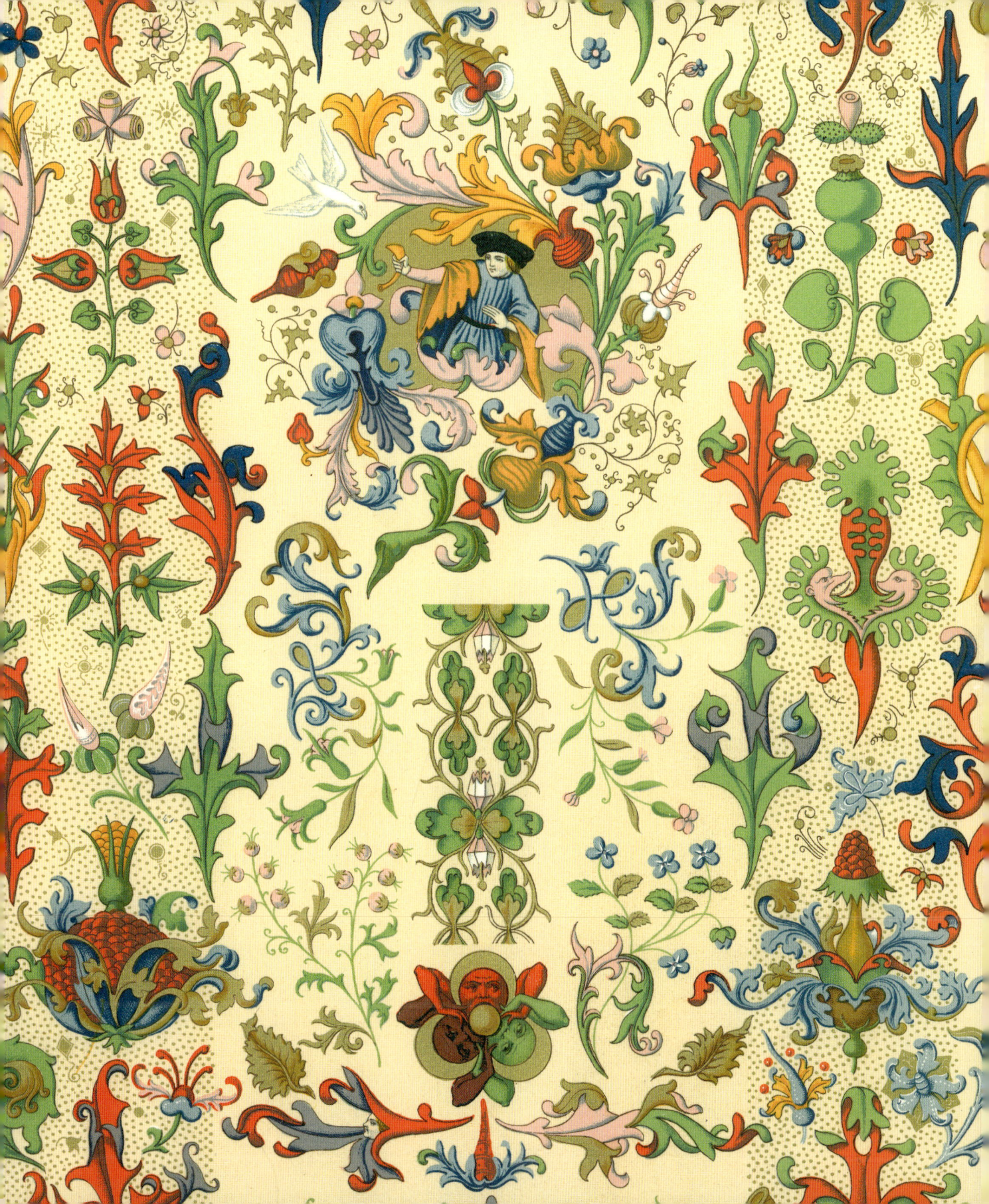

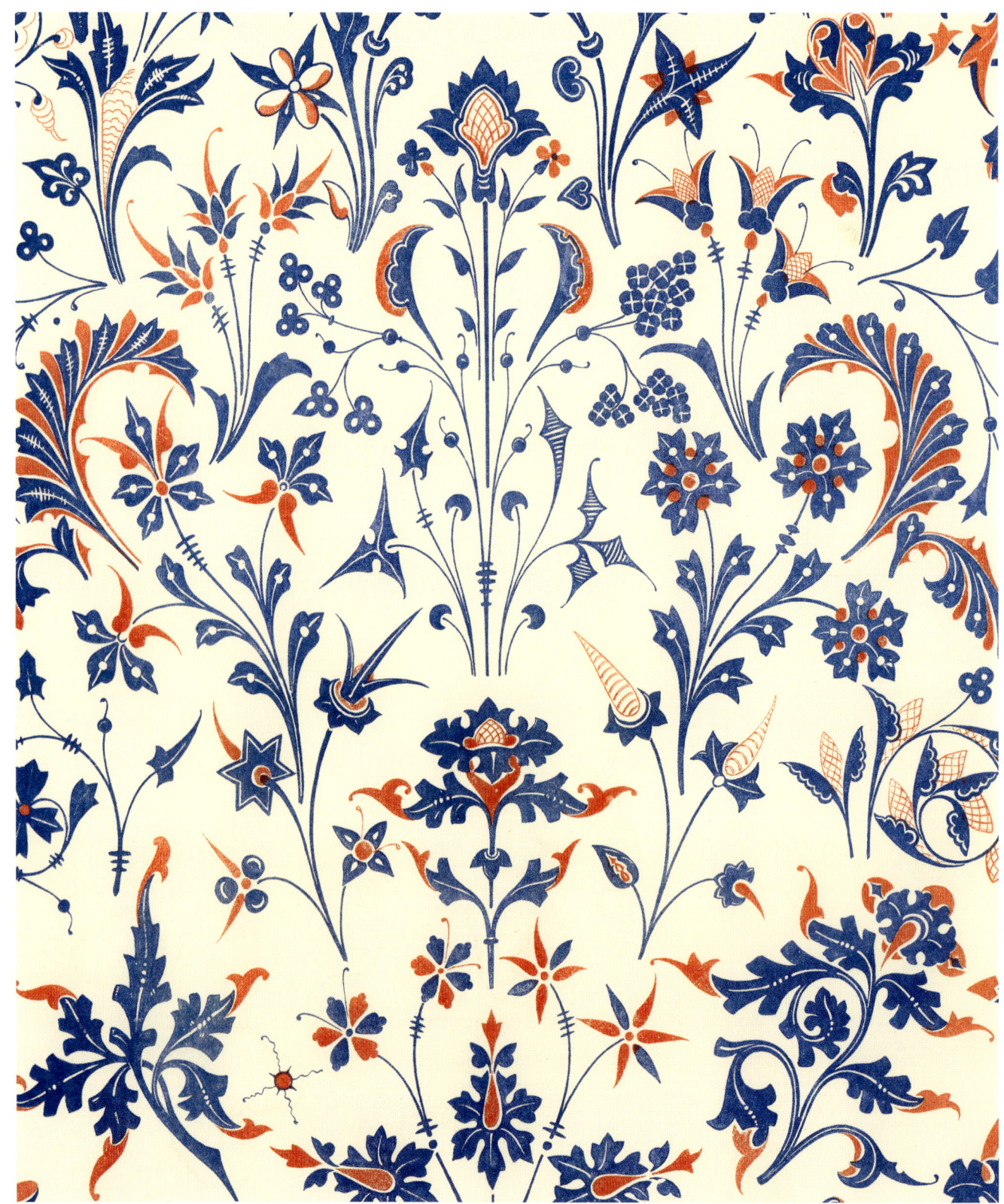

65–68

69

70

71

72

39

73 74

75 76

77

78

79

42

80

81

82

43

83

84

85

86

87

88

90

91

92 93 94 95 96

51

98

99

100

101

102

54

103

104

105

106

107

108

109

110

111

111

113

117

118

119

120

122

124

74

126

127

128

129–131

133, 134

135, 136

79

140 141 142

143

144

86

145

146

147

148

149

150 151

152

153

154

155 156 157

159

160

161

163

164

165

166

169

170

171

172

173

174

173

175, 176

177 178
179 181
180
182 183

106

184

185

186

187

188

189

190

191

107

192, 193 194, 195

196, 197 198, 199

200

201

202

203

204

110

205

206

207

208

209

111

210–213 214–217 218–221 222–225

226–229 230–233 234–237 238–241

113

242

243

244

245

246

247

248

115

249

250

116

251

253

254–256

257

258

259

122

260

261

123

262

263

264

265